BLINKY PALERMO

DIA ART FOUNDATION
NEW YORK

BLINKY PALERMO
October 9, 1987 through June 19, 1988

Library of Congress Catalogue Card Number: 87-72321
Copyright © 1987 Dia Art Foundation
All Rights Reserved
ISBN 0-944521-02-9

This publication has been made possible in part by the generous
support of the Cowles Charitable Trust and Daimler-Benz of North
America Holding Company, Inc.

This publication has been organized by Phil Mariani, designed by
Jean Foos and Jill Korostoff, typeset by Ultra Typographic Services,
and printed by Conrad Gleber Printing and Publishing.

Photography by Jon Abbott, except sketchbook (pp. 24-25)

CONTENTS

TO THE PEOPLE OF NEW YORK CITY

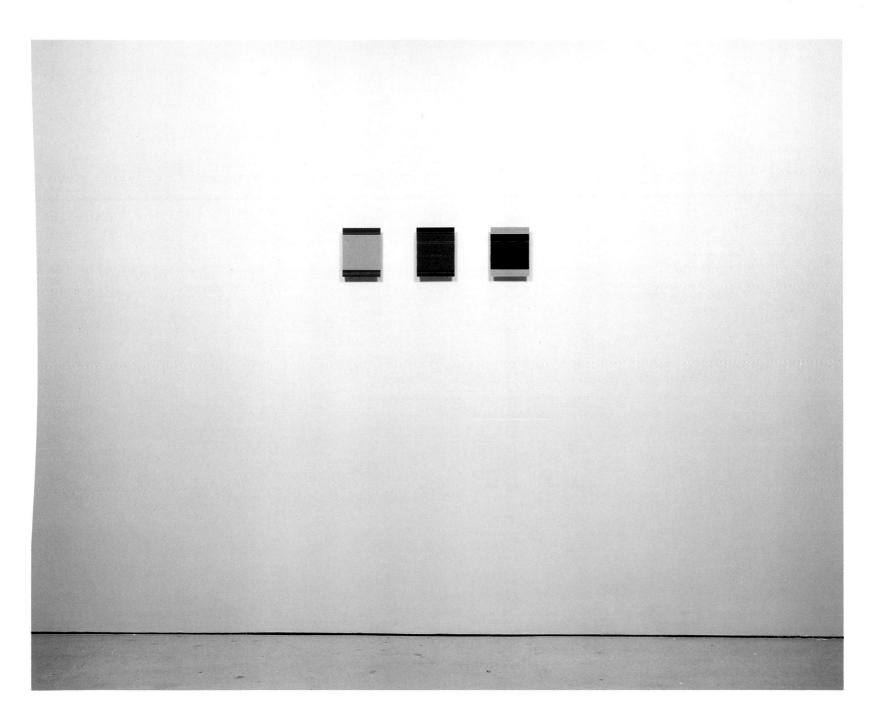

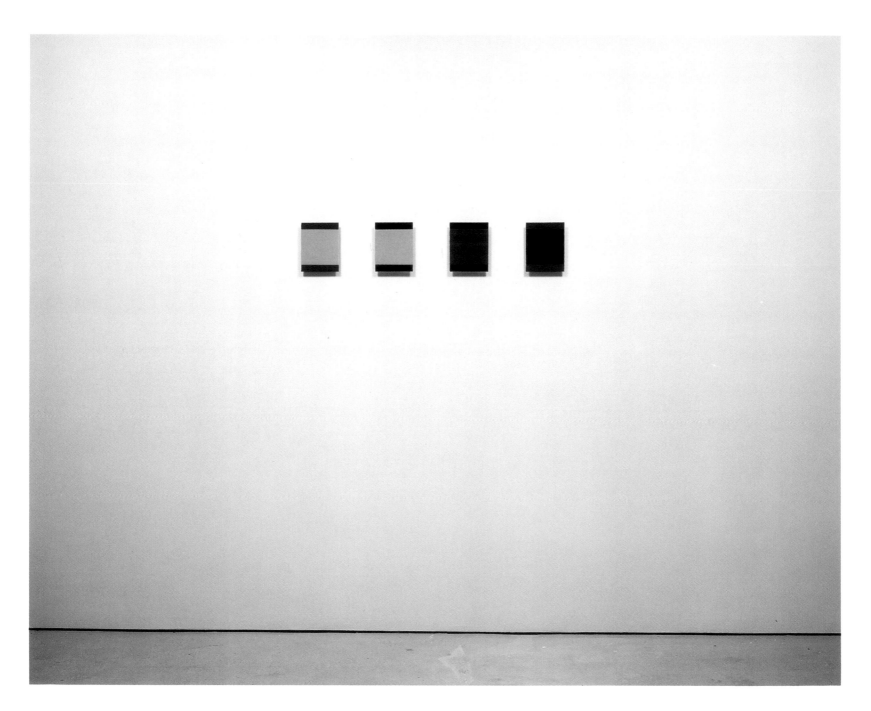

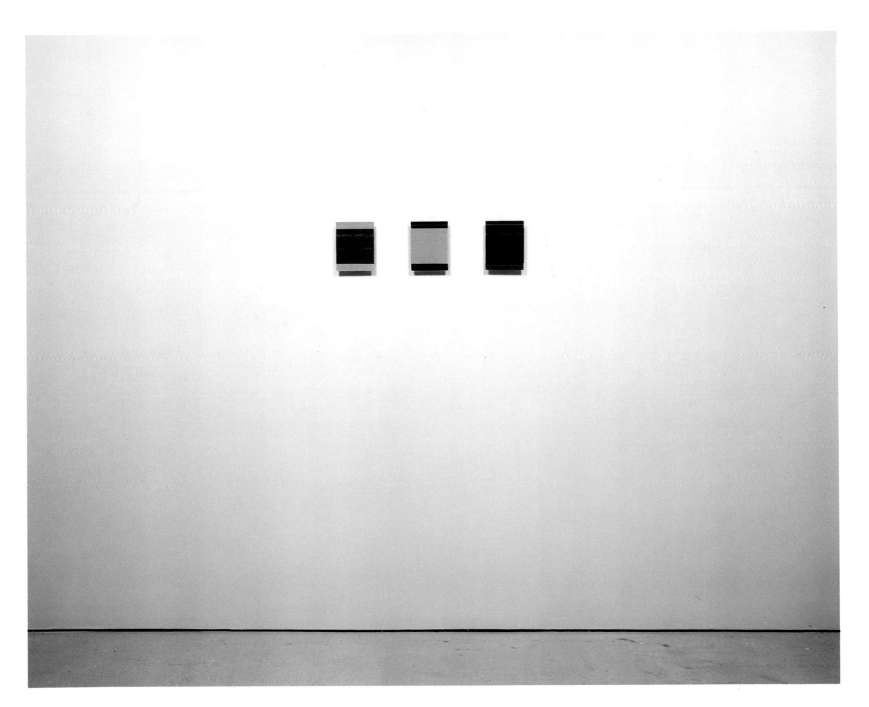

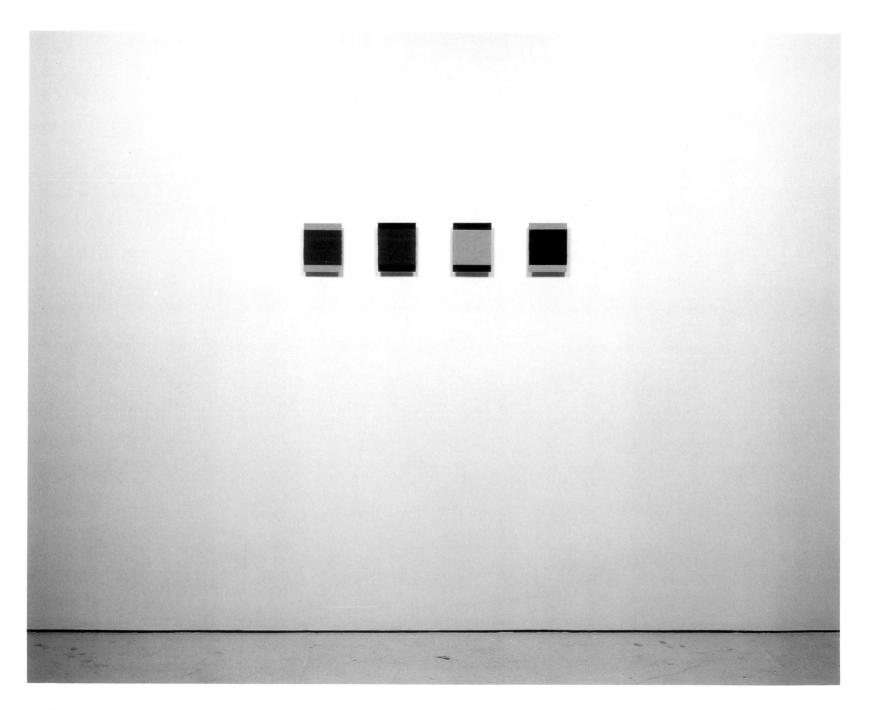

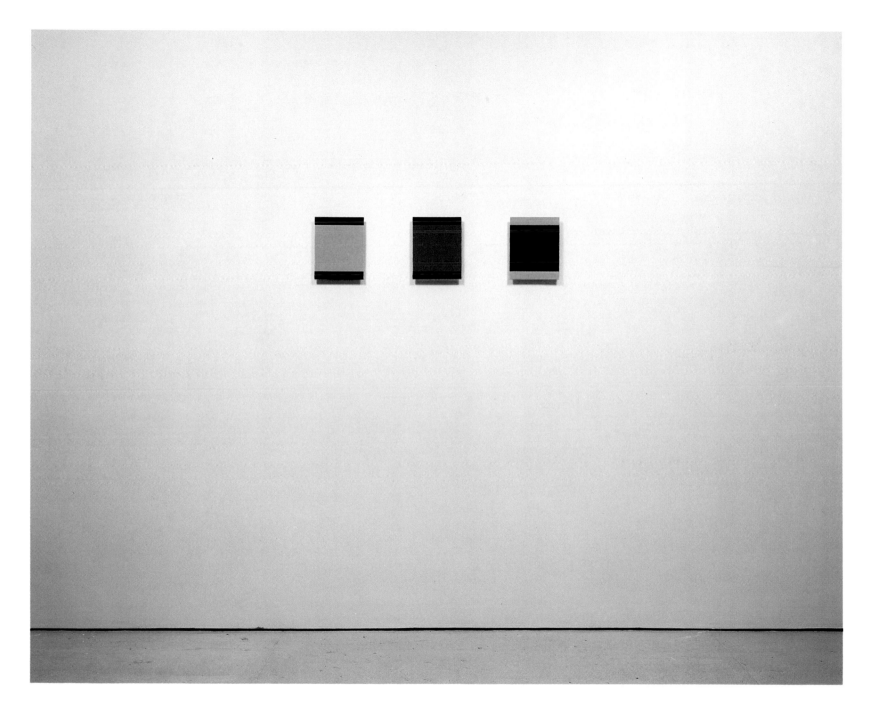

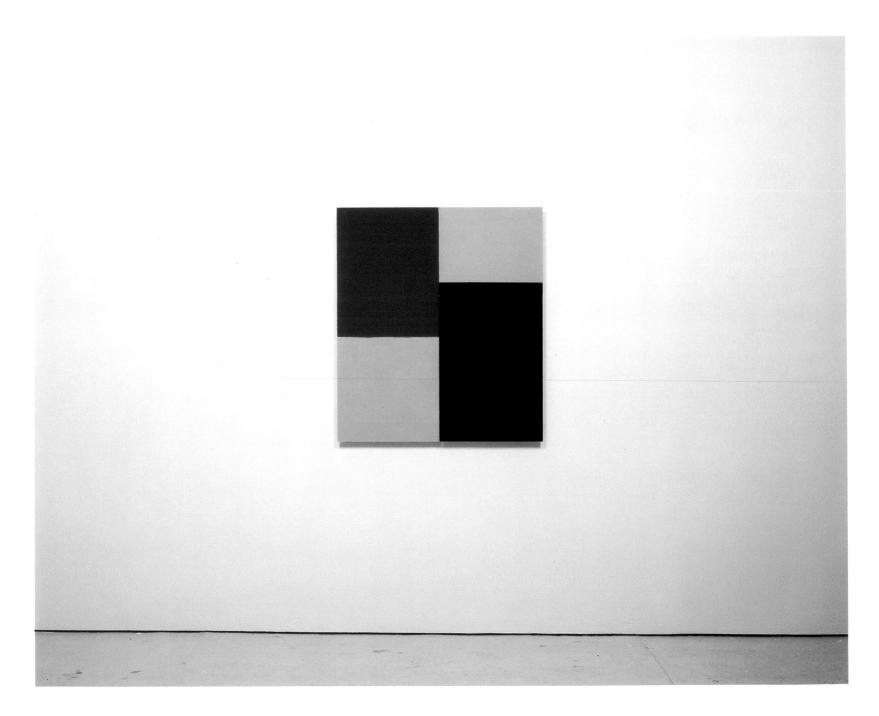

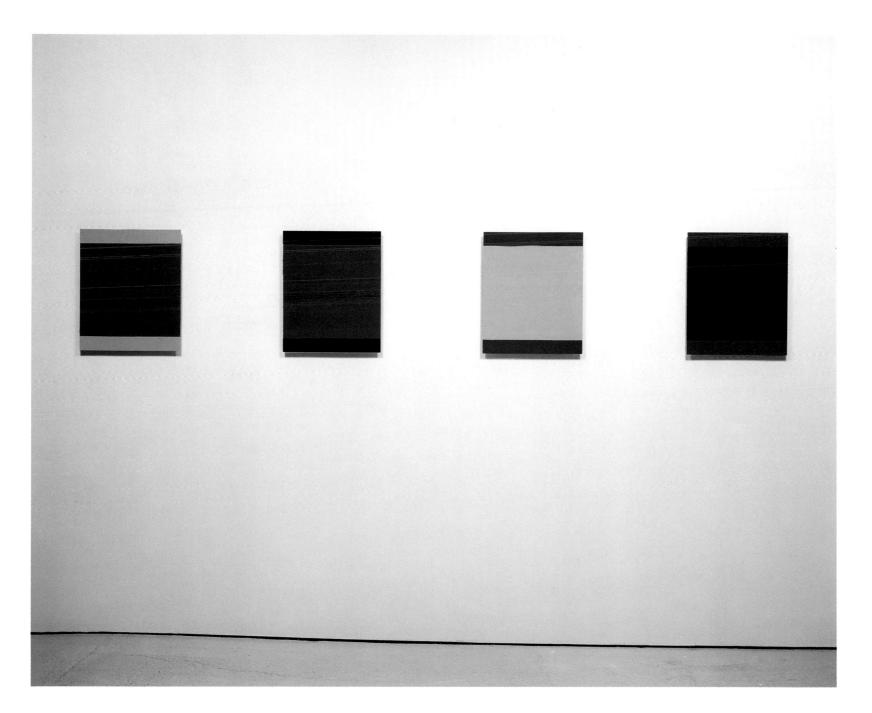

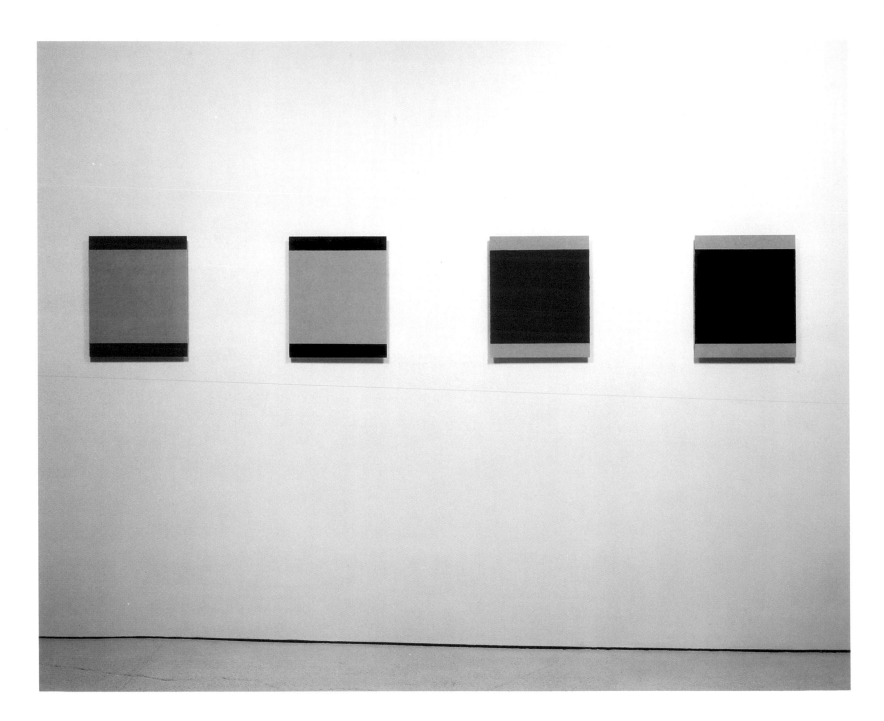

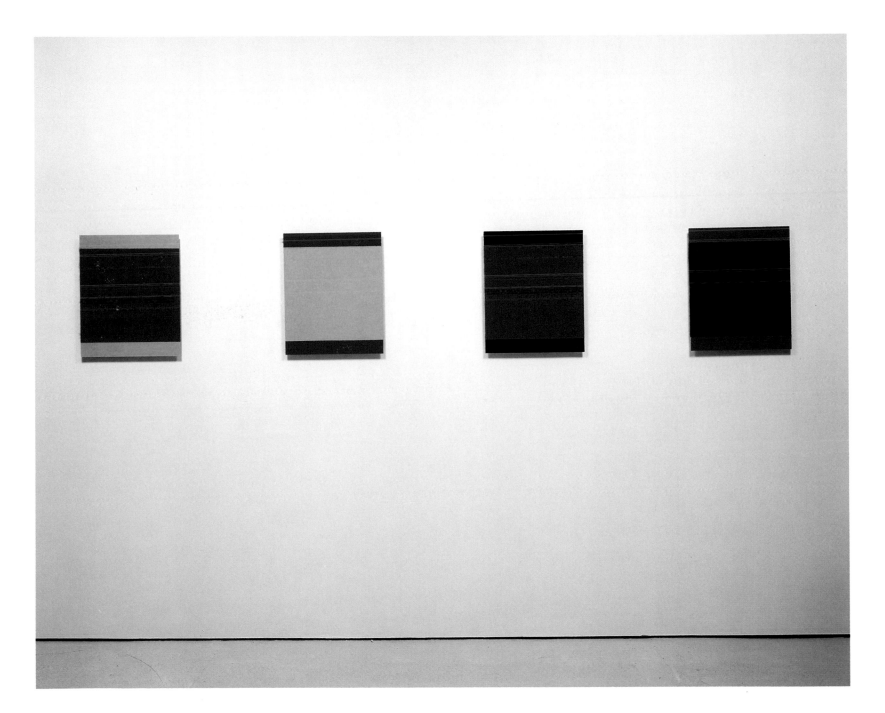

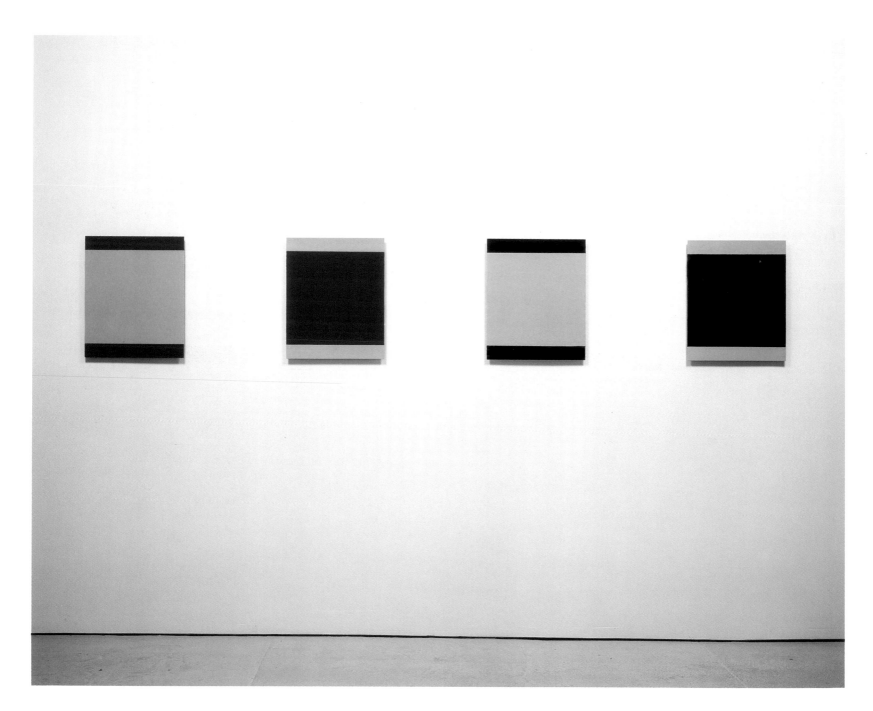

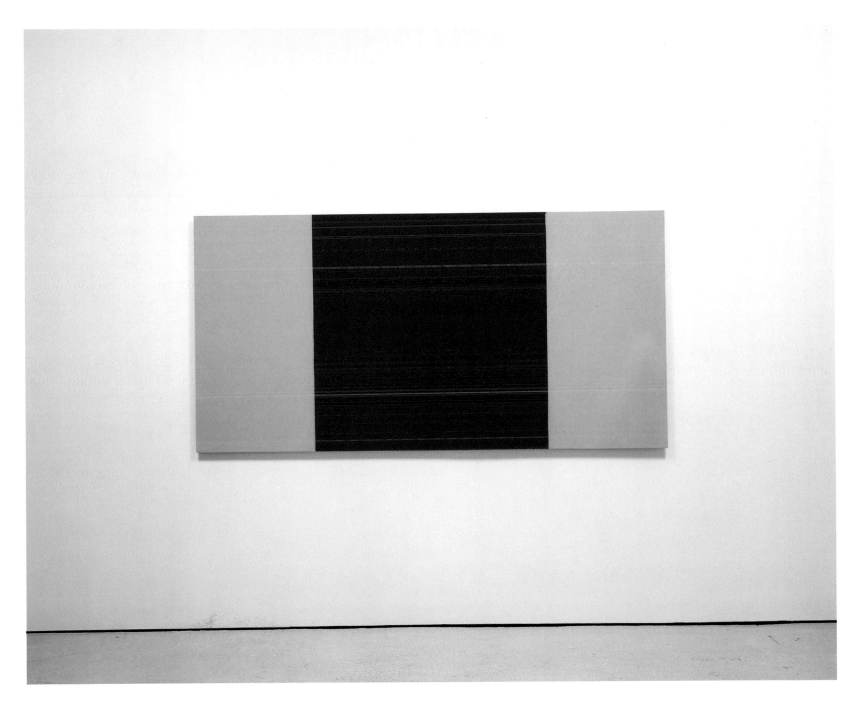

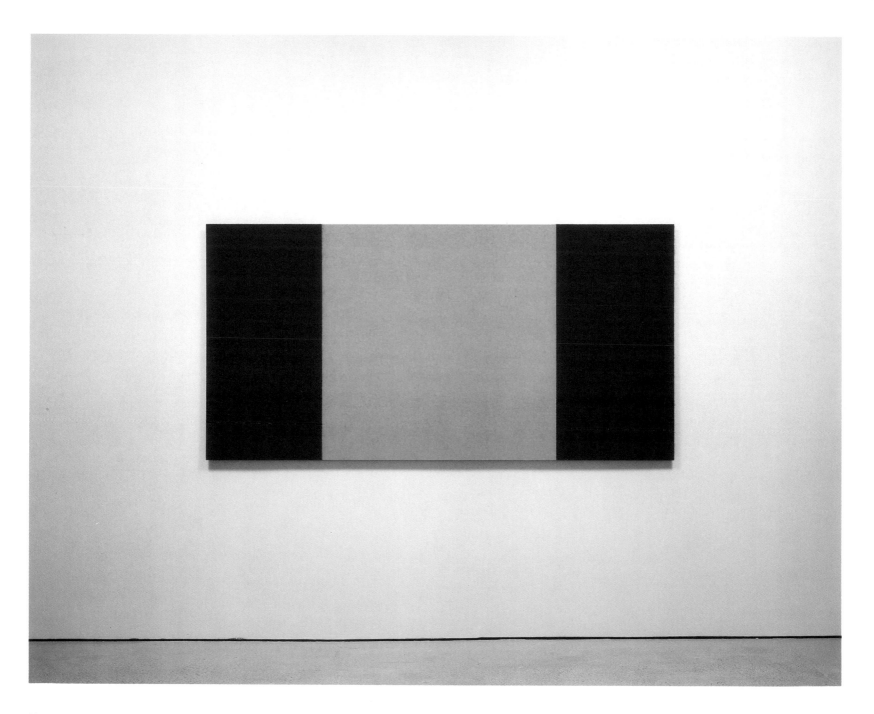

To the People of New York City / Part XII

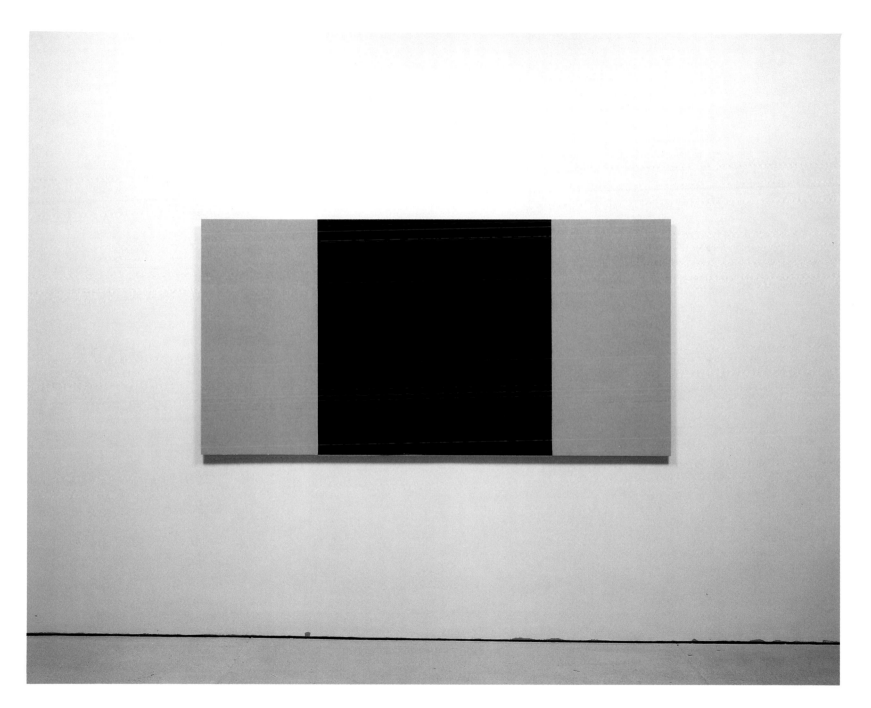

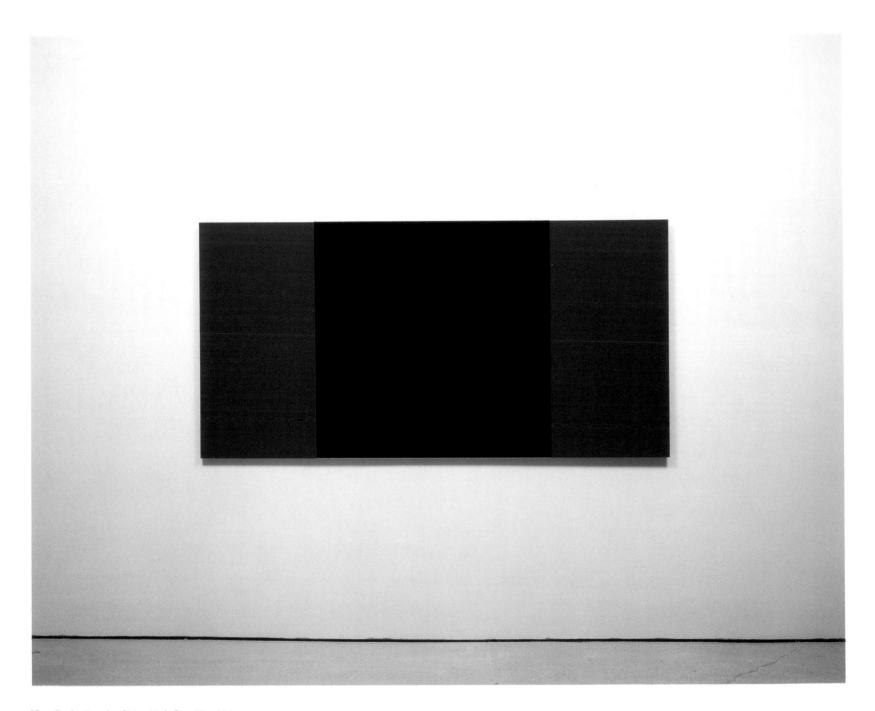

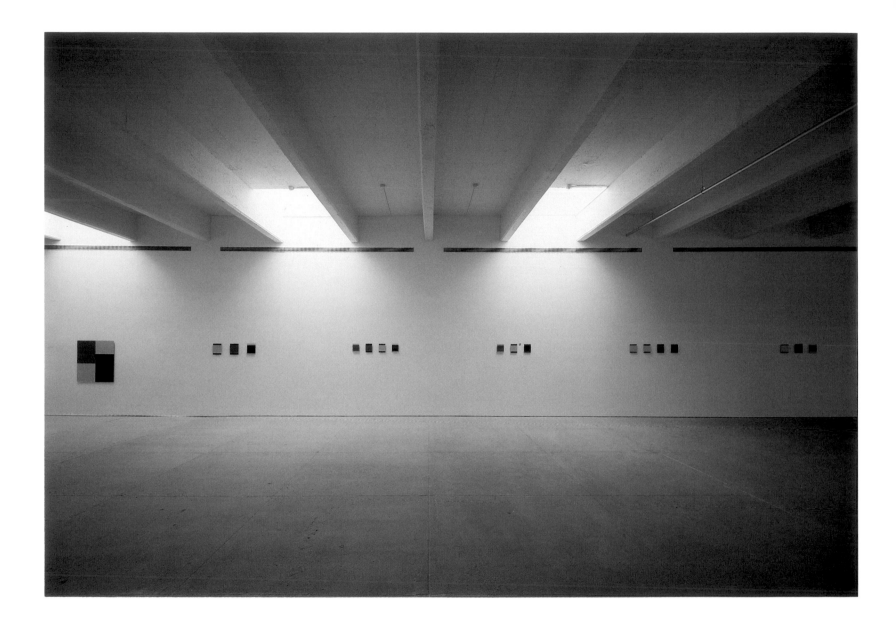

Installation view

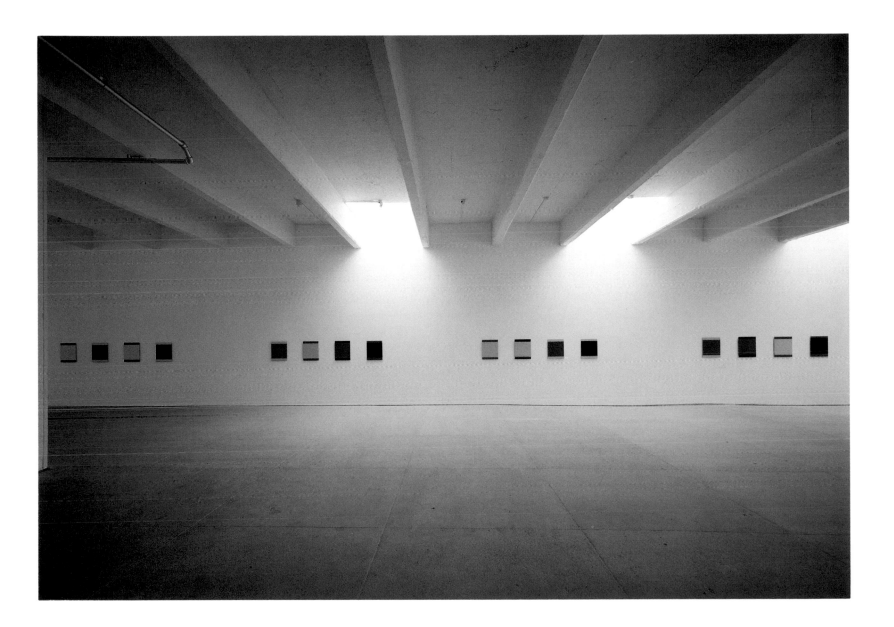

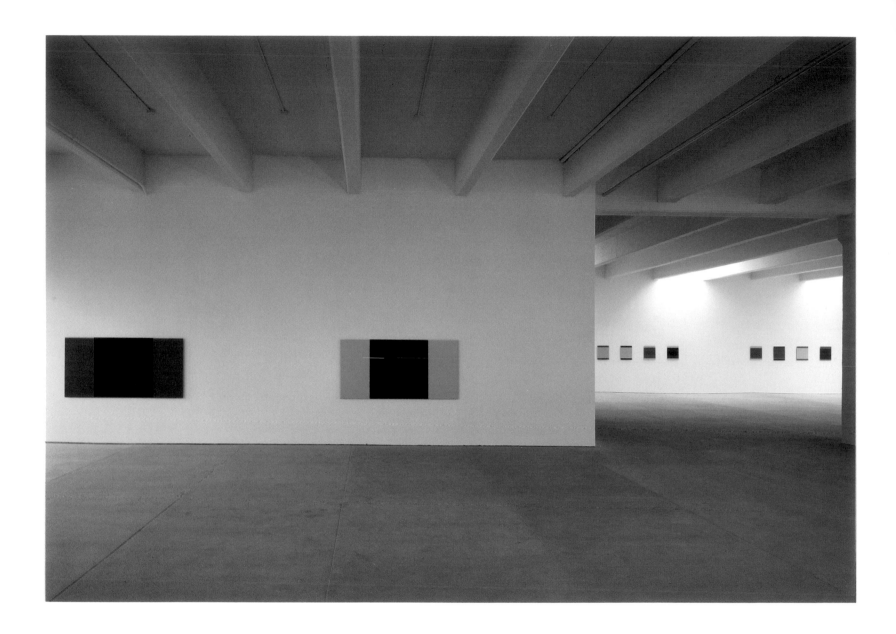

22 Installation view

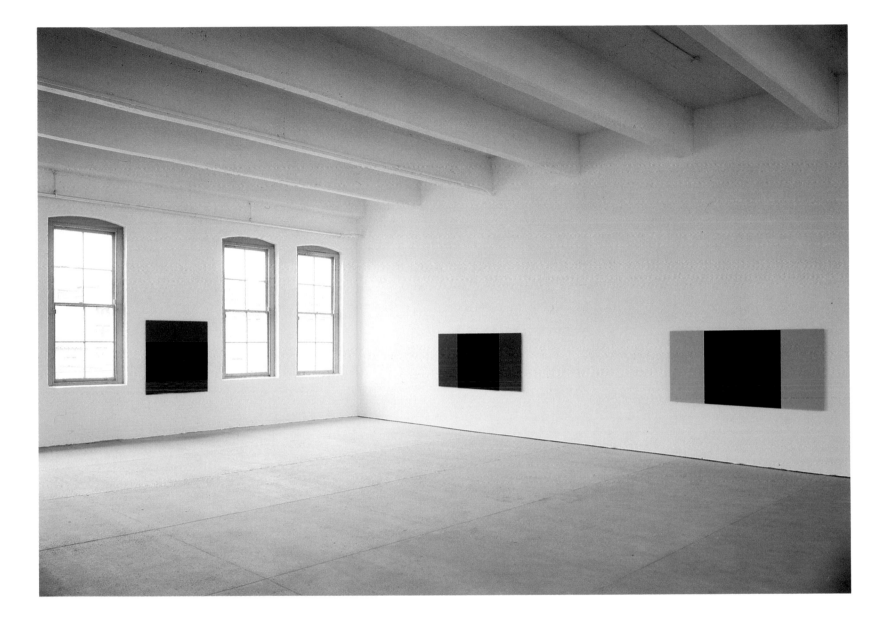

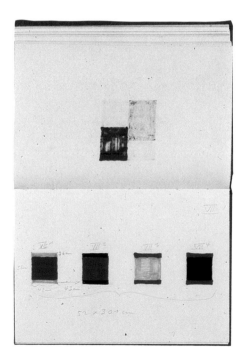

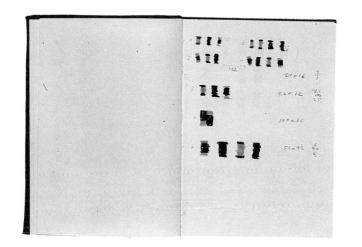

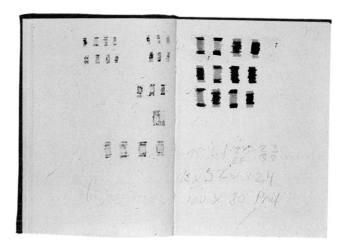

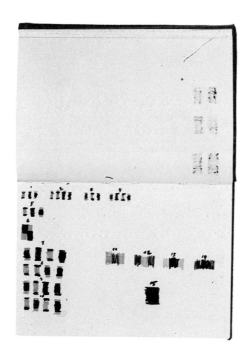

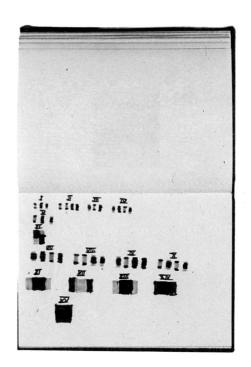

To the People of New York City is Palermo's last work, begun in 1976 in his studio in Düsseldorf and completed in January 1977 shortly before he left for the Maldive Islands where he died. It is composed of fifteen parts configured from forty aluminum panels with acrylic in bars and blocks of cadmium yellow, cadmium red, and black. Before this showing, it has been exhibited only once, from May 14—June 30, 1977, at Heiner Friedrich Gallery, New York. A sketchbook of Palermo's, partially reproduced here, documents the development of the composition of the panels.

Palermo chose aluminum as the support in this and other works because of its strength, allowing a thin sheet to be suspended from the wall .2 cm. thick for the smaller panels and .3 cm. for the large single panels. In the studio small aluminum bars were glued to the reverse of each panel. These bars supported the hanging of the panels and allowed them to be suspended in relief from the wall at a distance of 1.5 cm. for the smaller panels and 2.0 cm. for the large single panels. Additionally, they raised the panels when laid horizontally on a table keeping the edges clear while Palermo painted. As far as can be determined, Palermo did not pre-treat or work the surface of the aluminum but began by directly applying white acrylic gesso ground covering the surface and the edges. Acrylic paints were used directly from the tube without mixing. The cadmium yellow was produced by the English firm Rowney. The cadmium red and the black also probably were made by Rowney but with some possibility of coming from the German company Schmicke. Palermo worked without studio assistants and painted all the panels by himself with a brush.

From detailed examination of the panels and from what is known of Palermo's working methods, it is almost certain with nearly every panel that he painted the largest section—the central block—first and then taped over this area to paint the bars on either side. After removal of the tape, the taped area, a band ¼-inch to one inch wide, was repainted to remove the slight, linear residual impression left by the tape. The resulting slightly thicker paint surface obscures the distinctiveness of the original brushwork in these areas. In general, however, brushwork is horizontal and even across the panels. In no case is there any evidence of color areas overlapping. However, in isolated instances, Palermo did paint over entire sections. On a number of panels, cadmium yellow has been painted over a lighter, lemon yellow. In the large panels—Parts VI, XI, XII, and XIII—the lighter yellow can be read almost as a palimpsest under the cadmium yellow which has been applied in uneven strokes. On one small panel, Part VIIIa, the cadmium yellow completely covers the underlayer except in faint traces at the edges. It appears, and again from what is known of Palermo's intentions and methods, that this repainting was done not to achieve variable coloristic effects but rather because of dissatisfaction with the initially applied color. Other areas of repainting can be found only in Part III; in panel b, both the top and bottom bands initially were painted red and then repainted black; in panel c, the top band was initially painted yellow and then repainted red.

Throughout the panels, slight irregularities of paint application appear, such as raised spots due to excess paint from the brush, specks of scattered black or red paint bleeding through yellow, specks of black paint on red, and slight inconsistencies of line and bleeding of one area into another at the border between colors. Often in the removal of tape during the painting process, the tape would leave faint patterns or deformations in the paint film which were left unaltered. While most panels are consistent in the measurements of color bands, irregularities of between .1 and .5 cm. on the width of single color bands are frequent. Repainting to cover the impressions of taping, as noted before,

generally resulted in slight changes of surface and light refraction. In sum, all of the panels clearly and intentionally appear as rendered by hand, and although carefully planned and worked, minor chance incidents were left evident.

Palermo's decisions regarding composition in thirty-eight of the forty panels limited him to the use of combinations of red, yellow, and black, allowing only six permutations which he distributed in the following array:

red **yellow** **red**	Ia	IIa				VIIc	VIIIa	IXb	Xa	XII	
red **black** **red**		IId	IIIc			VIId		IXd		XIV	XV
yellow **red** **yellow**			IIIa	IVa		VIIa	VIIIc	IXa	Xb	XI	
yellow **black** **yellow**	Ic			IVd	Vc		VIIId		Xd	XIII	
black **red** **black**	Ib	IIc		IVb	Vb	VIIb		IXc			
black **yellow** **black**		IIb	IIIb	IVc	Va		VIIIb		Xc		

Each of these thirty-eight panels is divided into three color areas. Each permutation is used six times except for red/yellow/red and yellow/red/yellow which each are used seven times.

Part VI is the only part to break from the above plan of composition. It is composed of two panels, joined together by the supports to form a virtually seamless single panel, and so can be read either as a "panel" with four color blocks or as a diptych of two color areas in each panel.

Parts I, III, and V each are composed of three sets of panels; Parts II, IV, and VII-X each are composed of four sets of panels. All of these form strong horizontal compositions. Parts XI-XIV are single horizontal panels. Parts VI and XV read as single, vertical panels. In total, seven compositional variations are used: (1) Parts I and III; (2) Parts II and IV; (3) Part V; (4) Part VI; (5) Parts VII-X; (6) Parts XI-XIV; and (7) Part XV. Diagrams drawn to show the relationships and variations of size, scale, and composition are shown on the following pages with notations for dimensions and composition of color areas.

Parts I and III

3 cm.
15 cm.
3 cm.
each panel, 21×16 cm.
overall, 21×80 cm.

Part I

red	black	yellow
yellow	red	black
red	black	yellow

Part III

yellow	black	red
red	yellow	black
yellow	black	red

Parts II and IV

3 cm.
15 cm.
3 cm.
each panel, 21×16 cm.
overall, 21×112 cm.

Part II

red	black	black	red
yellow	yellow	red	black
red	black	black	red

Part IV

yellow	black	black	yellow
red	red	yellow	black
yellow	black	black	yellow

Part V

3.5 cm.
19.5 cm.
3.5 cm.
each panel, 26.5×21 cm.
overall, 26.5×105 cm.

Part V

black	black	yellow
yellow	red	black
black	black	yellow

Part VI

each panel, 100×44 cm.
overall, 100×88 cm.

Part VI	red	55.5 cm.	yellow	32 cm.
	yellow	44.5 cm.	black	68 cm.

Parts VII-X

6 cm.
40 cm.
6 cm.
each panel, 52×43 cm.
overall, 52×301 cm.

Part VII	yellow red yellow	black red black	red yellow red	red black red
Part VIII	red yellow red	black yellow black	yellow red yellow	yellow black yellow
Part IX	yellow red yellow	red yellow red	black red black	red black red
Part X	red yellow red	yellow red yellow	black yellow black	yellow black yellow

Parts XI-XIV

50 cm./100 cm./50 cm.
overall, 100 × 200 cm.

Part XI	yellow	red	yellow
Part XII	red	yellow	red
Part XIII	yellow	black	yellow
Part XIV	red	black	red

Part XV

36 cm.
67.5 cm.
21.5 cm.
overall, 125 × 110 cm.

Part XV	red
	black
	red

Palermo set the spacing within each multi-panel part at intervals equal to the widths of the panels themselves. He did not prescribe the spacing between parts. In this installation, we allowed 7'10¾" (2.39 m.) between Parts I, II, III, IV, V, and VI; 8'9⅝" (2.68 m.) between Parts VII, VIII, IX, and X; 5'11½" (1.82 m.) between Parts XI and XII; and 8'9¼" (2.67 m.) between Parts XIII and XIV. The heights of the panels, also not set by Palermo, were set here (measured to top of panel) at 69" (175 cm.) for Parts I, II, III, IV, V; 71¾" (182 cm.) for Part VI; 68" (173 cm.) for Parts VII, VIII, IX, and X; 70" (178 cm.) for Parts XI, XII, XIII, and XIV; and 78" (198 cm.) for Part XV.

As far as we can determine, there is no overall scheme regarding size and scale and their interrelationships reflecting a mathematical formula, theory, or progression. Analyzing dimensions and proportions of color areas, panels, and parts reveals few direct relationships. Only the vertical compositions, Parts VI and XV, have a one-to-one proportional relation, the horizontal dimension measuring .88 of the vertical dimension in both parts. The vertical dimensions of Part VI and Parts XI-XIV are equal, each measuring 100 cm. The increments in the shift of scale between individual panels in Parts I-IV, Part V, and Parts VII-X are closely joined; the proportion maintained between the horizontal dimension and vertical dimension of a single panel in Parts I-IV is .7619; in Part V, .7924; and in Parts VII-X, .8269; so that an increase of slightly over .03 is consistently found in each shift to a larger panel size.

G.G.

BIOGRAPHY

1943
Peter Schwarze, born June 2, in Leipzig; adopted with his twin brother Michael by Wilhelm and Erika Heisterkamp

1952
Moves to Münster

1954
Gymnasium Münster

1959
Boarding school in Burgsteinfurt

1961
Werkkunstschule Münster;
Begins relationship with Ingrid Denneborg

1962
Enters Kunstakademie Düsseldorf

1963
Class with Bruno Goller;
Class with Joseph Beuys, Master Student

1964
Takes the name Blinky Palermo (from the boxing promoter and Mafioso Blinky Palermo)

1965
Marries Ingrid Denneborg

1966
First one-person exhibition, Galerie Friedrich & Dahlem, Munich

1967
Finishes studies at Kunstakademie Düsseldorf

1968
Shares studio with Imi Knoebel

1969
Marries Kristin Hanigk;
Moves to Mönchengladbach and shares studio with Ulrich Rückreim

1970
Travels to New York with Gerhard Richter

1973
Travels in the United States with his wife Kristin in April;
Moves to New York in December;
Begins relationship with Robin Bruch

1974
Travels in the United States with Imi Knoebel, includes seeing Rothko Chapel in Houston and the *Las Vegas Piece* by Walter De Maria

1975
Divorce from wife Kristin

1976
Begins relationship with Babette Polter in Düsseldorf;
Sets up studio in Düsseldorf

1977
Travels in the Maldive Islands with Babette Polter;
Dies on February 17 in Malé;
Cremated in Sri Lanka, urn returned to Heisterkamp family grave in Münster

ONE-PERSON EXHIBITIONS

1965
Galerie Friedrich & Dahlem, Munich, paintings and drawings

1967
Galerie Heiner Friedrich, Munich, paintings and objects
Charlottenburg, Copenhagen (with Ruthenbeck)

1968
Galerie Konrad Fischer, Düsseldorf, *Stoffbilder*
Von der Heydt-Museum, Wuppertal, paintings and objects
Galerie Heiner Friedrich, Munich, wall drawings

1969
Kabinett für aktuelle Kunst, Bremerhaven, wall drawing
Galerie Ernst, Hannover, installation, *Räume*

1970
Palais des Beaux-Arts, Brussels, wall paintings (with Richter and Uecker)
Galerie Rudolf Zwirner, Cologne, paintings, drawings, objects

Galerie Konrad Fischer, Düsseldorf, "Treppenhaus"
Galerie Thomas Borgmann, Cologne, drawings and
watercolors
Galerie Ernst, Hannover, "Exhibition dedicated to Salvador
Dali" (with Richter), *Tuchverspannung* (fabric hanging)
Kabinett für aktuelle Kunst, Bremerhaven, wall paintings

1 9 7 1
Galerie Heiner Friedrich, Munich, wall paintings
Galerie Heiner Friedrich, Cologne, wall paintings and
sculpture (with Richter)
De Utrechtse Kring, Utrecht, wall paintings
Kabinett für aktuelle Kunst, Bremerhaven, wall paintings

1 9 7 2
Galerie Klein, Bonn, print survey
Diagramma, Milan, prints
Galerie Heiner Friedrich, Cologne, paintings (with Richter)
Galerie Heiner Friedrich, Munich, objects

1 9 7 3
Städtisches Museum, Mönchengladbach, objects
Kunstverein, Hamburg, wall paintings
Galerie Heiner Friedrich, Cologne, objects

1 9 7 4
Künstlersiedlung Halfmannshof, Gelsenkirchen, map works
Kunstraum, Munich, "Drawings 1963-73"
Galerie Heiner Friedrich, Munich, print survey

1 9 7 5
Institut für Moderne Kunst, Nuremberg, "Drawings 1963-73"
Städtisches Museum and Schloss Morsbroich, Leverkusen,
"Graphics 1970-74"
Städtisches Kunstmuseum, Bonn, "Drawings 1963-73"
Galerie Gunter Sachs, Hamburg, "Graphics 1970-74"
Galerie Heiner Friedrich, Inc., New York, drawings
XIII Biennale, São Paulo, metal paintings
Galerie Heiner Friedrich, Munich, "Happier than the Morning
Sun" prints, watercolors, and drawings dedicated to Stevie
Wonder

1 9 7 6
Galerie Heiner Friedrich, Cologne, drawings
Galerie Heiner Friedrich, Cologne, metal paintings

1 9 7 7
Galerie Heiner Friedrich, Inc., New York, "To the People of
New York City"
Galerie Centre, Oldenburg, prints
Museum Haus Lange, Krefeld, "Stoffbilder 1966-72" and
"Works on Paper 1974-77"

1 9 7 8
Galerie Heiner Friedrich, Munich, documentation of the
wall drawings
Galerie Heiner Friedrich, Inc., New York, works on paper
Galerie Klein, Bonn (with Beuys)

1 9 7 9
Galerie Foerster, Münster, prints and multiples
Galerie Heiner Friedrich, Cologne, prints

1 9 8 0
Kunstverein, Bremerhaven, prints and multiples
Galerie-Verein im Haus der Kunst, Munich, "Blinky Palermo
1964-76"
Dia Art Foundation, Cologne, "Blinky Palermo 1964-76"
Galerie art in progress, Düsseldorf, wall drawings and
wall paintings
Galerie Kubinski, Stuttgart, prints

1 9 8 1
Städtisches Kunstmuseum, Bonn, "Palermo"

1 9 8 4
Kunstmuseum, Winterthur, "Palermo Werke 1963-1977"

1 9 8 5
Kunsthalle Bielefeld, "Palermo Werke 1963-1977"
Stedelijk Van Abbemuseum, Eindhoven, "Palermo Werke
1963-1977"
Centre Georges Pompidou, Musée national d'art moderne,
Paris, "Palermo Oeuvres 1963-1977"
Marian Goodman Gallery, New York

1 9 8 7
Sperone Westwater, New York
Dia Art Foundation, New York, "To the People of
New York City"

ACKNOWLEDGMENTS

The Dia Art Foundation has organized three inaugural exhibitions, each to be shown for a year (through June 1988), for a new public exhibition space at 548 West 22nd Street, New York: sculpture and drawings by Joseph Beuys (1921-1986); paintings, sculpture, and drawings by Imi Knoebel; and a single painting of many parts by Blinky Palermo (1943-1977). The works are drawn largely from the permanent collection of the Dia Art Foundation. Between 1974 and 1984 the Foundation collected extensively the works of a small number of artists including, principally, Beuys, Chamberlain, De Maria, Flavin, Judd, Knoebel, Newman, Palermo, Sandback, Twombly, and Warhol. These inaugural exhibitions, therefore, present aspects of the Foundation's collecting activity.

It has been almost ten years since Blinky Palermo died at Malé in the Maldive Islands on February 17, 1977. This work, titled *To the People of New York City,* composed of fifteen parts with a total of forty panels, was Palermo's last and one of his most ambitious works.

We are grateful to Imi Knoebel, who assisted us with the installation. Dana Cranmer carefully examined the panels and provided valuable information for our technical note. Thordis Moeller generously permitted us to review her files and records on Palermo. We also thank Tom Zummer for his diagrams of the individual panels. Phil Mariani's help was invaluable in the coordination of the production of the catalogues for these inaugural exhibitions. The staff of the Dia Foundation, including Joan Duddy, Assistant to the Director; Gary Carrels, Director of Programs; James Schaeufele, Buildings Manager; and Margaret Thatcher, Administrator, have worked with particular dedication under occasionally difficult conditions to open this new project to the public and to help realize these inaugural exhibitions. The Board of Directors of the Foundation, with its encouragement and support, has made this new public project possible.

Charles B. Wright
Executive Director